THE GREAT DETECTIVE
SHERLOCK HOLMES

— THE MYSTERY OF THE VAMPIRE II —

List of Main Characters

Sherlock Holmes

London's most famous private detective. He is an expert in analytical observation with a wealth of knowledge. He is also skilled in both martial arts and the violin. He resides in 221B Baker Street in London.

Watson

Holmes's most dependable crime-investigating partner. A former military doctor, he is kind and helpful when help is needed.

Alice

The daughter of 221B Baker Street's landlady's relative. She has such a sharp tongue that even Holmes is intimidated by her.

Gordon "Gorilla" Riller and Carlson Fox

Scotland Yard's detective duo. They love to show off, but their investigating skills are rather clumsy. They often need help from Sherlock Holmes.

Catalia

Ferguson's wife

Robert Ferguson

An old school friend of Gorilla's

Jack

Ferguson's son and Alice's schoolmate

Old man

suspected to be a vampire

THE GREAT DETECTIVE
SHERLOCK HOLMES
—— THE MYSTERY OF THE VAMPIRE II ——

註釋凡例

內文每頁底部均附有較深生字的中文解釋。

英文生字	中文解釋

mansion (名) 大宅、建築物

語法術語簡稱

名——名詞 noun

動——動詞 verb

形——形容詞 adjective

副——副詞 adverb

片語 phrase

片語動——片語動詞 phrasal verb

習——習語 idiom

限——限定詞 determiner

明白了！

唔…很詳細呢。

Fright Night

"You tell me, Devon! How should we handle this?" said an angry woman named Barbara as she questioned her husband.

"Erm…erm…" Afraid to look at his wife, Devon *hummed and hawed* with his head down, "Well… Let's wait for a few more days… I'll come up with a plan…"

"You'll come up with a plan?" *growled* Barbara in fury. "Every time I ask you, you always say you'll come up with a plan! It has been months but it feels like an eternity already! What have you come up with so far? Tell me!"

hum(med) and haw(ed) (片語) 支支吾吾、吞吞吐吐
growl(ed) (動) 不滿地說、咆哮　　eternity (名) 永恆

"Well…erm… This is no ordinary matter. I need time to plan thoroughly…"

"Plan? What exactly do you need to plan? It's such a simple matter. We have a large piece of rubbish here and it has been an eyesore for too long. Can't you just chuck it somewhere in the woods?" bombarded Barbara. "If you don't want anyone to see you in the act, then head off further where no one could see you! The further, the better! I've had enough. I don't want

eyesore (名) 礙眼的東西　bombard(ed) (動) 轟炸、連珠炮發

to see that large piece of rubbish here anymore! I will literally spew if I were to lay eyes on it one more day!"

"But...but no matter how far I go, someone would discover..." hesitated Devon. "What if it traces back to us upon discovery? That would be terrible..."

"Are you really that thick?" berated Barbara as she poked Devon's head with her finger. "All you have to do is figure out a way that it won't be discovered!"

"How...how could that be possible?" Devon sneaked a cowardly peek at his wife before he continued, "Like you said, it is a large piece of rubbish. Someone would notice right away if I were to take it to the streets..."

"I guess you really are that thick!" shouted Barbara in

fury. "You can use our cargo carriage, you fool! Just shove that large piece of rubbish into the cargo carriage then cover the carriage with a sheet of canvas. This way it will stay out of sight from all eyes."

"But…what about when I chuck it? Someone could easily see me…" Devon closed his eyes and took a step back after saying those words, hiding his head between his hunched-forward shoulders, bracing for his wife's deafening shouts.

But Devon did not hear any shouting. Even the angry loud **exhalations** from his wife seemed to have disappeared. Finding it odd, Devon opened his eyes slowly and turned towards the direction of his wife.

As his eyes met his wife's, Devon could feel chills running down his spine then spreading all over his body.

hunched-forward (形) 弓前的　　bracing (brace) (動) 預備迎接　　deafening (形) 震耳欲聾的
exhalation(s) (名) 呼氣

Those were a pair of frigid eyes, **detached** and soulless, empty and hollow, like the glare from a deceased corpse!

"Bury it," said Barbara in an exceptionally calm tone, which was unusual of her. "Find a place out of sight from the world and bury that large piece of rubbish there. This way, no one would ever discover it."

Devon did not dare to believe what he had just heard, but his wife's words kept echoing in his ear.

Bury it... Bury it... Bury it...

On this dark night, besides the cries of frogs and bugs, the wind did not make a sound. The quietness felt unbearably chilling.

Devon's entire body was soaked in sweat, yet he was not feeling hot at all but chilled to the bone instead. He

frigid (形) 冰冷的 detached (形) 抽離的、冷漠的 hollow (形) 空洞的
corpse (名) 屍體 bury (動) 埋藏 unbearably (副) 難以忍受地

knew very well that seeping out from his pores was nervous cold sweat.

Lit with nothing but one weak candlelight, Devon stared blankly at the dark 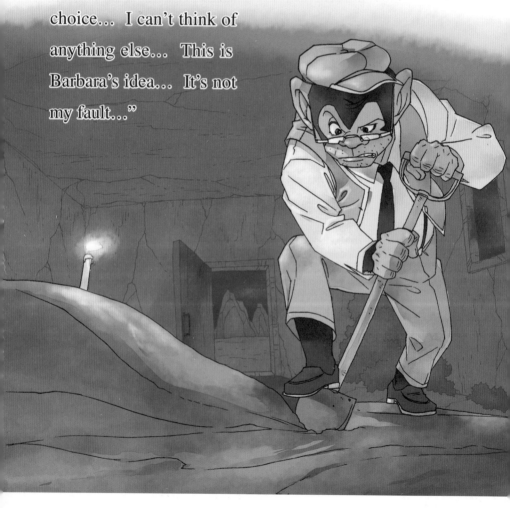 pit by his feet and muttered to himself, "Please forgive me... I don't really have a choice... I can't think of anything else... This is Barbara's idea... It's not my fault..."

pore(s) (名) 毛孔　 pit (名) 坑洞

Devon kept on whimpering as he lifted the earth beside the pit with his **shovel** and threw the earth *arduously* into the pit.

Just at that moment, two voices sounded from outside. Startled by the noises, Devon immediately stopped moving and perked up his ears.

"I need to take a wee. I'm about to burst," said a man's voice. "Do you need to go too?"

"I can feel nature's calling on me too, but **rumour** says that spirits roam around this area. Perhaps it's not a good idea to relieve ourselves here."

"I thought you're a gutsy fellow. Don't tell me you believe in such silly rumours?"

shovel (名) 鏟、挖　arduously (副) 拚命地、艱難地　perk(ed) up (片語動) 豎起
nature's calling (片) 人有三急　rumour (名) 謠傳、傳聞

"But…"

"Stop dawdling! If you're not joining me, I'll go by myself over there."

"Okay, alright."

As the talking and footsteps grew nearer, Devon blew out the candle at once then walked to the doorway for a peek. He could see a swinging oil lamp not too far away. Holding the lamp were two men approaching his direction. Stunned to see those two men, Devon quickly picked up his shovel, left the premises and disappeared into the darkness.

dawdling (dawdle) (動) 慢吞吞、浪費時間　　peek (名) 偷看、一瞥
left the premises (動) 離開現場

Just then, the two men had reached closer, with the man holding the oil lamp at the front and the other man following behind.

"I can see a door in front of us. Let's go inside."

"Okay."

The two men walked through the doorway as they spoke.

"Perhaps this is an abandoned stone chamber. I **reckon** it's a perfect makeshift toilet," chuckled the man holding the lamp. "I don't think anyone would mind."

"Eh? Do you see that pile of earth in the centre?"

"You're right. What is it?"

Forgetting about their call of nature for the moment, the two men walked curiously around the pile of earth to see if there was anything behind.

reckon (動) 認為

Under the lighting of the oil lamp, they noticed a large hole in the ground.

"Someone has dug a pit here. That pile of earth must've been from the digging."

"Could this…be a grave?" asked the other man frightfully. "Maybe someone was robbing this grave…"

"No way…"

"Argh!"

"What is it?"

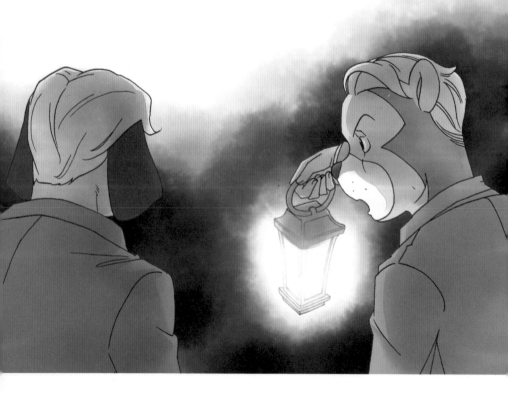

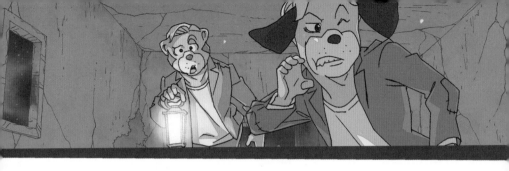

"Something is touching my leg!"

"What?" The man with the lamp extended his arm to shine the lamp on his companion's leg.

"Aarrgghh!!" screamed both men.

Under the weak lighting of the oil lamp, they could see that gripping the man's leg was a bony hand reaching out from the pit!

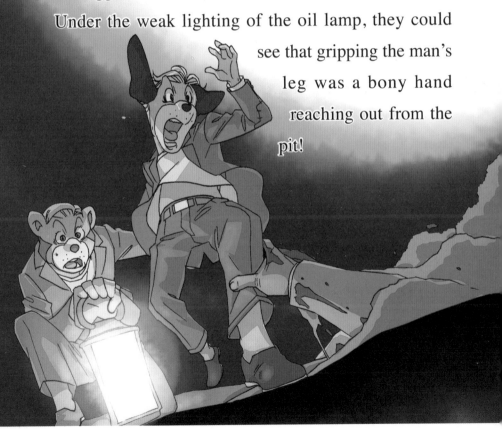

The two men were scared **stiff**. Before they could

even collect their senses, a **ghastly** face began to appear

from the pit and a pair of **bloodshot** eyes glared right at

stiff (副) 極度　　ghastly (形) 恐怖的、慘白的　　bloodshot (形) 充血的、血紅的

the two men.

"Aaarrrggghhh!!!" screamed the two men in extreme fear. The man holding the oil lamp ran off immediately. When the other man had finally shaken his leg free from the grip of the bony hand, he ran **frantically** after his companion who was holding the oil lamp. Scared out of their wits, the two men dashed out of the stone chamber as quickly as they could and ran into the darkness outside.

frantically (副) 拚命地、慌忙地

The Mystery of the Vampire

The sun was already travelling westward by the time Sherlock Holmes and his group of five arrived at Ferguson's estate in Lamberley.

Half a year ago, a dead body was discovered at a nearby desolate graveyard. Rumours began to spread, saying that Count Dracula had crawled out of his grave and turned into a vampire killing people. The rumours threw the townspeople into a constant state of fear, but the truth was finally unveiled with the help of Holmes's investigation. The so-called vampire turned out to be nothing but a false alarm. Unveiling the truth had also saved Ferguson's family from the brink of shattering.*

*For more details, please read *The Great Detective Sherlock Holmes: The Mystery of the Vampire.*

westward (副) 向西方　　desolate (形) 荒涼的　　brink (名) 邊緣
shatter(ing) (動) 破碎、粉碎

As a gesture of thanks for helping him half a year ago, Ferguson had invited Sherlock Holmes, Dr. Watson, Alice along with police detectives Carlson Fox and Gordon "Gorilla" Riller to stay at his countryside estate for holiday.

"Gordon, it's so nice to see you again!" Ferguson had been waiting for them by the front door of his mansion. He leaned forward to greet them as soon as he saw the horse-drawn carriage pulling up.

gesture of (名+介) 為表示

"Ferguson, my mate, you are looking good! Looks like the vampire hasn't sucked your blood dry!" Gorilla and Ferguson were old friends from secondary school. They had always spoken cheekily to each other.

"Please don't poke fun at me and my wife. I don't think she would be too happy if she were to hear you," said Ferguson as he let out a sheepish chuckle.

"That's right," chided Watson. "Gorilla really shouldn't be cracking such bad jokes."

"That's how he is. He never thinks before he speaks," said Fox, always ready to jump on any opportunity to tease Gorilla.

"Nonsense! I certainly don't mind at all," said Ferguson's wife, Catalia, as she stepped out of the front door. "If it weren't for the help from Mr. Riller and the rest of you gentlemen, the suspicion of me being a vampire wouldn't have been cleared. I really could not thank you enough."

"Hello, Mrs. Ferguson," greeted Alice as soon as she saw Catalia.

"Oh, you must be Alice," said Catalia with a smile.

suck(ed) (動) 吸食　　cheekily (副) 放肆地、嘲弄地
poke fun at someone (習) 嘲笑某人　　sheepish (形) 不好意思的、羞怯的
chide(d) (動) 斥責　　tease (動) 嘲弄、取笑　　suspicion (名) 懷疑

"I've heard so much about you from Jack."

There was a **rift** in the past between Catalia and Jack, the son from Ferguson's first marriage. However, after Ferguson took up Holmes's advice and sent Jack to the same boarding school as Alice, Jack and Catalia began to get along like family again.

ft (名) 不和、分歧

"Where is Jack?" asked Alice. "He has gone hunting with two male servants. He says he wants to catch two pheasants and have them served to you for dinner," said Catalia with a smile.

"Jack has gone hunting?" asked Holmes curiously. "Looks like the socially awkward boy from half a year ago has made much progress."

"What socially awkward boy?" protested Alice. "Jack is a very cheerful and popular boy at school."

After hearing those words, Holmes let out a chuckle and asked in a teasing tone, "Someone here is very ready to defend for Jack. Could it be because you like him?"

"Like him?" Alice gave Holmes a

pheasant(s) (名) 野雞、山雞

sidelong glare as she continued, "I happen to like most people, except for those who are always falling back on their rent."

"Late rent…?" Holmes looked at Alice *aghast*.

Alice wrapped her arm around Watson's arm and said, "I like Dr. Watson the most, because he is a kind man and he always pays his rent on time." Alice then leaned on Gorilla and said, "Mr. Riller is also a good man. Last time when he lost his bet, he paid up straightaway without uttering a word of objection. What's not to like about him?"

"Is that so?" said Gorilla with a bashful smile and blushing cheeks.

"Always talking about money. So not adorable for a young girl. Just like a vampire,

fall(ing) back on (片語動) 不按時、延遲　aghast (形) 驚惶失措、駭然的
blushing (形) 臉紅的　adorable (形) 可愛的、討喜的

in a sense." Holmes immediately changed the subject since Alice's words were hitting Holmes right where it hurt most. "I reckon a real vampire is probably more adorable than you!"

Watson could not resist a **muffled** chuckle. He knew too well that Alice was Holmes's **nemesis**. Every time Alice brought up his late rent, this great detective from London must come up with something quickly to evade the subject.

"You are all too playful!" said Ferguson, trying his best to be the peacemaker. "Our home is going to be so lively in the coming days with you lot staying over."

"Father!" The group's attention was instantly diverted towards the yelp. Turning their heads around,

muffled (形) 壓低的　　nemesis (名) 剋星、宿敵　　evade (動) 迴避

they could see Jack approaching them with the two male servants following behind him.

Running towards Ferguson in **distraught**, Jack was out of breath as he spoke, "Father! A vamp…vampire has appeared again!"

"What?" Ferguson was shocked when he heard those words.

"Dear boy, are we playing that game again?" said Fox lightly. "Remember how we solved the vampire mystery you created last time? Are you having new ideas again?"

"No… This time…is probably real!" said

distraught (形) 心煩意亂的、焦慮不安的

Jack with fear in his eyes.

"There is no such thing as vampire in this world. Don't be misled by superstition, my boy," said Gorilla, adopting the lecturing tone of a teacher.

"Mr. Riller is right. There is no such thing as vampire in this world. There's no need to scare yourself like that," comforted Catalia.

"Mother, I wasn't a believer before," said Jack. "But when we were hunting in the woods, we ran into several villagers and they told us they saw a vampire wandering about by the graveyard at the ruins of Count Dracula's estate."

"Really?" asked Ferguson. "Or maybe they're just spreading fabricated hearsay. There are always so many ghostly rumours about that place."

"No…sir," said a trembling male servant as he stepped forward. "The villagers didn't seem to be spreading

superstition (名) 迷信　　fabricated (形) 偽造的、虛構的　　hearsay (名) 謠言

rumours by the look on their faces. According to one of the villagers, in the middle of the night three days ago, two men from another town passed by a dug up grave and the vampire grabbed one of the men's leg!"

"Oh……" Everyone gasped with chills running through the spine after hearing the male servant speak with such conviction.

"Hehehehe…" sounded a light yet eerie laughter all of a sudden from behind the group.

Everyone turned around, only to find Holmes chuckling giddily with a grin so wide that his sharp canine teeth were visible.

"I haven't had a case in the last two months and I'm

eerie (形) 怪異的　giddily (副) 輕浮地　grin (名) 笑容

bored stiff. How incredible is it that this area is haunted once again! It's perfect timing for me to exercise my almost rusty brain," said Holmes.

Gorilla swallowed a nervous gulp and asked apprehensively, "Exercise…your rusty brain? What do you mean by that?"

"What do I mean by that?" said Holmes with a shrewd grin on his face. "You and Fox might not believe in vampires, but somebody has now seen one with his own eyes. It's the perfect timing for us to show off our skills."

"You mean…we should go catch the vampire?" asked the jittery Fox.

"Aha! You read my mind," said Holmes lightly. "The sun hasn't begun to set yet so we should have enough time to go take a look at the Count's graveyard. And if we happen to see a vampire while we're there, we could catch him and bring him back here."

"What…? Catching a vampire?" shouted the spooked Gorilla. "We're here on holiday, not

apprehensively (副) 擔心地　　shrewd grin (形+名) 胸有成竹的笑容
jittery (形) 緊張的、不安的　　spooked (形) 受驚的

catching vampires!"

"That's right! Let's not create complicated matters for ourselves. We should just relax and enjoy Mr. Ferguson's **hospitality**. Let's just wine and dine and take it easy." Fox's jitters were showing on his face, but he tried to sound laid-back nevertheless, "I'm sure everyone agrees with me, right?"

"Only a moment ago you were saying that vampires don't exist in this world. And now you're suddenly so scared of them? You two are useless," said Alice as she shot a sidelong glance at the Scotland Yard duo.

"Me? Scared of vampires? Don't be **daft**! I'm not scared of them!" said Gorilla with his face flushed red.

"That's right! Why would we be scared of a vampire?" Fox quickly puffed up his chest and put on airs, "We are Scotland Yard's dynamic detective duo. It's the vampire who should be scared of us!"

"Is that so?" challenged Alice. "Then why don't you two go along with Mr. Holmes to find this vampire?"

The Scotland Yard duo looked over to Ferguson then

hospitality (名) 殷勤款待、熱情好客　　daft (形) 愚蠢、胡鬧

to Catalia and Jack. They knew there was no way to back down now, or they would look too cowardly in front of everyone. At last, they had no choice but to reply in unison , "Of course! We're not scared at all!"

"Hooray! We are exploring the graveyard again!" cheered Alice in excitement.

"Should we really go there?" asked the worried Jack.

"Yes, yes, yes!" shouted Alice. "It's going to be so exciting and fun! You should come with us!" Alice took a firm hold of Jack's hand after saying those words.

The puzzled Ferguson looked over to Holmes and did not know what he should do.

in unison (習) 異口同聲

Sensing Ferguson's concern, Holmes said to Ferguson lightly, "Don't worry. Your son will be safe with us."

"Let Jack go with them so he could see how Mr. Holmes approach an investigation. Boys must learn to build courage and take risks in order to become a man," said Catalia.

"Okay," nodded Ferguson to Holmes. "I shall leave Jack to you then. My wife and I will have dinner prepared for you all. Please come back before the day turns dark."

"Dinner preparations? Do you need help? I'm a pretty good cook," volunteered Gorilla right away.

"No, I think you should go catch the vampire. I will help with the cooking," said Fox. "I make a mean steak. I promise

you the flavours will be absolutely unforgettable."

"Aren't we all going together to catch the vampire? Why are you two scrambling to be the cook?" said the displeased Alice. "Is someone trying to wriggle out?"

"Nonsense!" shouted Gorilla and Fox in unison. "We are only offering our help."

"Thanks for offering, but our kitchen maids will do the dinner preparations. You go and catch the vampire,"

mean (形) 出色的　flavour(s) (名) 味道　scrambling (scramble) (動) 爭先恐後
wriggle out (片語動) 設法擺脫、逃避

said Ferguson lightly.

"Alright then…" Seeing there was no way to evade the **inevitable**, Gorilla said to Ferguson, "Do you mind if I borrow something from your kitchen? I will be right back." After saying those words, Gorilla ran into the mansion like a *gust* of wind to find the kitchen.

"The kitchen? What is he up to?" asked the confused Fox.

Holmes let out a chuckle and said, "Take a guess. He must've gone to pick up something that could **ward off** vampires."

"Something that could ward off vampires…?" Fox thought for a moment before the answer came clear to his head. "That selfish ape! He didn't ask me to go to

inevitable (形) 難以避免的　　gust (名) 一陣(風)　　confused (形) 迷惑的、混亂的
ward off (片語動) 擋住、驅趕

the kitchen with him!" After saying those words, Fox also darted into the mansion.

"They're acting weird. What are they up to?" asked the **bewildered** Watson.

"You don't get it?" Holmes leaned towards Watson and whispered in his ear, "They've gone to the kitchen to borrow some garlic."

"Oh!" Watson then remembered how Gorilla and Fox made fools of themselves last time when they fought over a string of garlic while conducting an investigation at the graveyard.

bewildered (形) 困惑的

Count Dracula's Graveyard

An hour later, Holmes and his group of six arrived at the ruins of Count Dracula's estate.

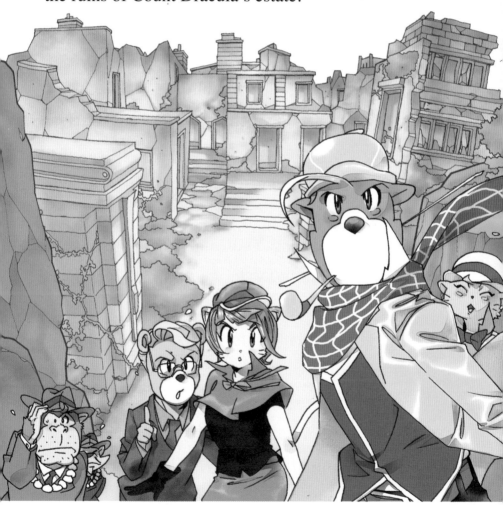

"It was early spring the last time we were here. I remember it was a bit cold. We haven't been back for half a year and now everywhere is covered with grass," said Holmes as he surveyed the site of ruins.

"Yes," said Watson. "Even though it's almost dusk now, it still feels rather hot with the sun above our heads."

Wearing strings of garlic around their necks, Gorilla and Fox followed timidly behind Holmes and Watson. They kept raising their heads to look up to the sky that they almost tripped over rocks several times as they walked.

Finding the Scotland Yard duo's behaviour very strange, Jack asked, "Why do you keep looking up to the sky? Are you worried that it might rain?"

"We're just on the lookout for crows," said Gorilla.

"Yes, we need to be cautious, in case we see any crows," said Fox.

"Crows? You don't have to worry about them. The crows in this area are very shy. They don't attack

timidly (副) 戰戰兢兢地　　trip(ped) over (動+介) 絆倒　　cautious (形) 小心、謹慎、提高警覺

36

people," said Jack.

Alice let out an icy chuckle and said, "They're not afraid of crows. They're afraid of vampires."

"Vampire?" Jack was taken aback. "What does a vampire have to do with crows?"

"Don't you know?" said Gorilla, in all apparent seriousness. "Crows like to be close to vampires. Anywhere with vampires would definitely have…"

"Kraa!" cawed a crow flying over their heads all of a sudden.

"Argh!" yelped Gorilla and Fox as they jumped into each other's arms in fear.

"Please don't get stirred up over nothing," snorted Holmes. "Your screams are loud enough to scare away everything, even

apparent (形) 明顯的　stir(red) up (片語動) 激動起來、大驚小怪
snort(ed) (動) 氣哼哼地說、不滿地說

37

a vampire!"

Upon hearing Holmes's words, Gorilla pushed Fox off his arms and complained to Jack, "It's your fault. All your questions have diverted our attention, otherwise we wouldn't be frightened by the crow."

"How dare you blame someone else for your own cowardice," **retorted** Alice.

"Okay, that's enough," said Holmes. "Please stop **bickering**. We've come here to catch a vampire, not to start a quarrel."

"But how do we go about catching a vampire?" asked Watson.

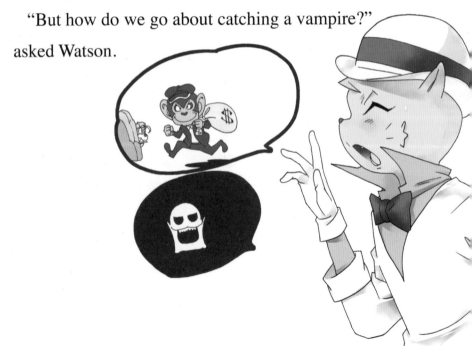

retort(ed) (動) 反駁、反擊　bicker(ing) (動) 爭吵

"I know how to catch a crook, but I've never tried to catch a vampire before."

"Why should there be any difference in catching a crook and catching a vampire? All we need to do is treat the vampire's haunting ground as a crime scene and look for clues and leads that are worth pursuing," said Holmes. "Let's not waste any more time and start looking for clues."

As the chatter went on, they had already passed the ruins and reached the graveyard. Gorilla and Fox, however, had deliberately stayed behind instead of walking closer.

"There's nothing here," said Watson after a quick look around. "Even the grave that was dug up last time has been repaired."

"No discovery? That's good. Let's go back," shouted Gorilla.

crook (名) 壞人　　deliberately (副) 故意地　　dug up (片語動) 掘起

"You guys take your time. We will go back first," shouted Fox also.

Without waiting for Holmes's response, the duo turned around to leave right away. However, after only a few steps, the duo suddenly stopped and began to walk backwards shakily.

"What is it?" asked the puzzled Holmes and Watson as they walked towards the duo.

"That…that…" stammered Gorilla and Fox as they pointed at the ground before them.

Following the direction of their pointing, Holmes could see a snake of about five to six feet long on the ground.

"It's just a snake. No need to be so frightened," said Holmes as he rolled his eyes.

"That's just a grass snake. It isn't poisonous," said Jack as he walked near the duo. "We have many snakes

like this one in the area. There's no need to be afraid."

"I see. Sorry but we live in the city and rarely see any snakes, so we can't tell if it's poisonous or not," said Gorilla as he forced himself to calm his nerves. "That's why I was quite taken aback just now."

"Argh!" screamed Alice all of a sudden by the graveyard as she pointed at a tombstone. "Behind... behind... I think there is..."

Before she could even finish her sentence, a swaying shadow appeared from behind the tombstone. All in the group were stunned speechless when they saw his face.

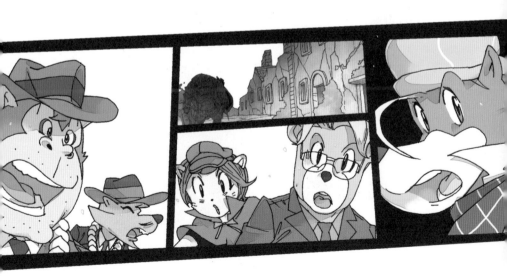

rarely (副) 極少 swaying (形) 搖晃的

The man had **dishevelled** hair and was wearing ragged clothes. With **cracks** all over the skin on his face and his eyes bloodshot red, the man slowly *wobbled* towards them from behind the tombstone.

"Vamp…vampire…!" Gorilla and Fox were so frightened that their legs went limp and could not move.

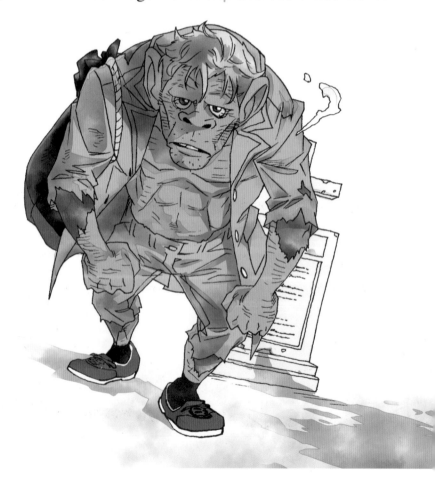

dishevelled (形) 凌亂的 crack(s) (名) 裂紋、裂縫 wobble(d) (動) 搖晃
limp (形) 無力

Even though Alice did not believe in the existence of vampires, she was also scared stiff, hiding behind Jack and Watson, refusing to go nearer.

Holmes, on the other hand, was not scared at all. He asked in a loud voice, "Sir, what are you doing here?"

As though he could not hear Holmes's question, the dishevelled man gave the group a quick look then turned around shakily to leave.

"Please don't go!" said Holmes as he *lunged* forward and blocked the man. "Who are you? Why are you acting like a haunting spirit and scaring off people?"

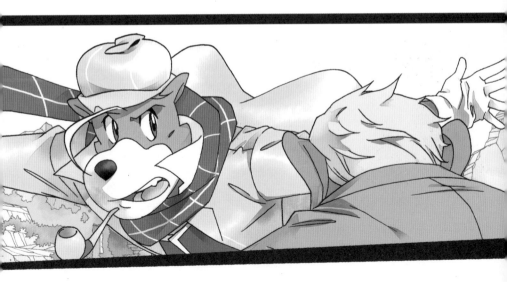

lunge(d) (動) 衝向、撲向

Offering no response, the man bypassed Holmes and kept limping slowly onwards. However, after a few ⸨wobbly⸩ steps, he keeled over all of a sudden, his body **slumped** onto itself like a deflated ball.

wobbly (形) 搖晃的、顫抖的　　slump(ed) (動) 倒下　　deflated (形) 洩氣的

The Vampire in the Pit

"**Blimey!**" Everyone was greatly taken aback.

Holmes quickly went to check on the man. He knelt down for a closer look and said, "This man must be over seventy years old. His skin is very dry. He must be severely dehydrated and very weak physically."

"Are you sure? Are you seeing him clearly? He could... be a vampire," uttered Gorilla nervously.

"Yes. Maybe he isn't thirsty for water but thirsty for...blood instead!" spoke the fearful Fox with his lips **quivering**.

"Is that so? Then let's have him suck a bit of your blood so he could quickly **replenish** his

blimey! (感嘆) 哎呀、天呀！　　dehydrated (形) 脫水　　nervously (副) 緊張地
quiver(ing) (動) 顫抖　　replenish (動) 補充

nutrition," said Holmes with a deadpan face.

"Don't be absurd! We're not going to feed a vampire with our own blood!" protested Gorilla and Fox.

"Come on, you two, Holmes is only joking with you," said Watson. "Let me take a look at him." After saying those words, Watson walked over to the old man then knelt down to conduct a medical assessment.

"Hmmm…" After checking the pulse on the old man, Watson took a look at the cracks on the old man's skin and said, "He is very weak indeed. He seemed to have been exposed to the sun for a long period of time, so long that the top layer of his skin has shed."

"Jack, didn't you bring some water with you? Please let this old man drink some of your water first," said Holmes as he held up the old man's head. Jack handed his canteen to Holmes right away, then Holmes carefully poured some water into the old man's mouth.

The old man opened his mouth in a daze and held onto the canteen with his right hand. After several desperate gulps, he gradually regained his consciousness.

deadpan (形) 嚴肅的、面無表情　　absurd (形) 荒謬的　　medical (形) 醫學的
assessment (名) 評估　　shed (動) 脫落　　in a daze (片語) 迷糊地
desperate (形) 嚴峻的、拚命的　　gulp(s) (名) 吞嚥　　regain(ed) (動) 恢復

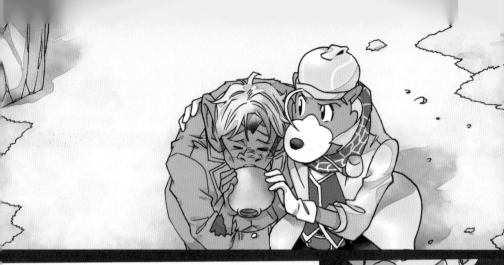

"There are two teeth marks in his arm!" said Jack as he pointed at the old man's arm.

"What? Two teeth marks?" exclaimed Gorilla frightfully. "Could they be the doings of a vampire?"

Holmes and Watson took a careful look at the teeth marks. They then raised their heads and exchanged **enigmatic** smiles with each other.

"Can you give me a bulb of

enigmatic (形) 神秘的

your garlic please?" asked Holmes to the Scotland Yard
duo.

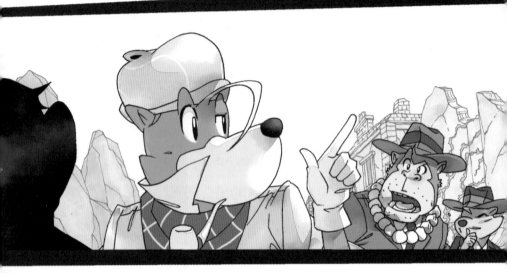

"Garlic? Do you need them for your own protection?"
asked the stunned Gorilla.

"Don't tell me that you've confirmed those teeth
marks are from the biting of a vampire?" Fox took a
step back in fear before continuing, "Anyone bitten by a
vampire would also turn into a vampire!"

"You are right. He will turn into a vampire very
soon," said Holmes as he let out a cold smile that
flashed his canine teeth. "He is about to wake up. I'm

stunned (形) 震驚的　　canine teeth (名) 犬齒

sure you don't want me to get bitten by him. You must understand that if I were to turn into a vampire, I would be the strongest vampire in history."

"Yes, yes, yes! Please take the garlic!" Gorilla snapped off a bulb from his string of garlic and threw it to Holmes at once.

Holmes caught the bulb of garlic with one hand then *shoved* it into his mouth and began chewing.

"We need to eat them now?" Gorilla and Fox were so spooked that they **followed suit** and began **munching vigorously** on the strings of garlic around their necks.

Holmes, however, only

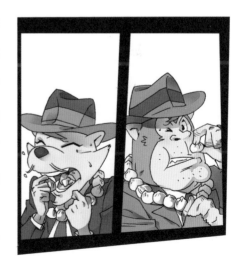

shove(d) (動) 塞進　follow(ed) suit (片語動) 跟着做、有樣學樣
munch(ing) (動) 咀嚼、咬　vigorously (副) 用力地

chewed the garlic bulb for a few seconds to break it into smaller pieces. He then spat out the small pieces of garlic and placed them under the old man's nose.

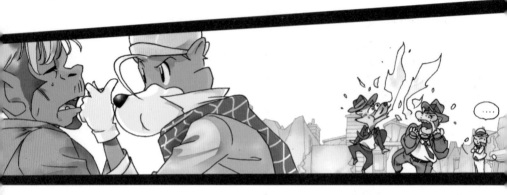

"Mr. Holmes, what are you…?" asked the **puzzled** Alice.

Holmes let out a shrewd chuckle and rolled his eyes over to the Scotland Yard duo, who was now screaming in pain from the garlic's *pungent* spiciness in their mouths. "Garlic is very **acrid**. Letting the old man smell garlic would hopefully wake him up quickly," said Holmes.

"Oh, I see! You tricked…"

"Hush! Keep your voice down. Don't let them hear you," said Holmes to Alice with a *cheeky* grin

puzzled (形) 困惑的 pungent (形) 刺鼻的 acrid (形) 辛辣的 cheeky (形) 頑皮的

on his face.

Just then, the old man slowly opened his eyes. He appeared to have woken up fully.

"He's awake," said Watson.

"Aha! The garlic worked!" said Holmes with a smile.

"Sir, can you tell us your name please? Why are you roaming around in this graveyard?" asked Watson to the old man.

The old man looked at Watson but did not offer a reply. He gently freed himself from Holmes's arms and tried to stand up. At the sight of this, Gorilla and Fox immediately stopped screaming and took a few apprehensive steps backwards.

"Shall we find a place to take a rest, sir? You are still very weak physically," said Holmes to the old man.

Without offering a response, the old man just kept taking wobbly steps forward, just as he was right before he *keeled over*.

"Isn't he…a vampire? Why is he like this?" asked Gorilla after the old man had walked off a distance.

apprehensive (形) 擔心的、不安的　　keel(ed) over (片語動) 倒下

"Perhaps he is just a homeless man with mental problems," said Watson. "The villagers must've seen him lurking by the graveyard and mistaken him for a vampire."

"Perhaps. One thing we know for sure is that he isn't originally from this village, or else the villagers would've recognised him instead of mistaking him for a vampire," said Holmes.

"So what should we do now? Just leave him here?" asked Alice.

"We can't do that. He can't even walk steadily. If he weren't properly cared for, he would soon keel over again and maybe even die here," said Jack worryingly.

"You are right. I don't think he can last more than a few days in his condition,"

lurk(ing) (動) 藏匿、潛伏

said Holmes. "Let's follow him and see where he is heading."

The group followed the old man with Holmes taking the lead, moving slowly in accordance to the speed of the old man's **limping** steps. Paying no attention to the group behind him, the old man kept walking alone on his own. Perhaps he was not even aware that a group of people was following behind him.

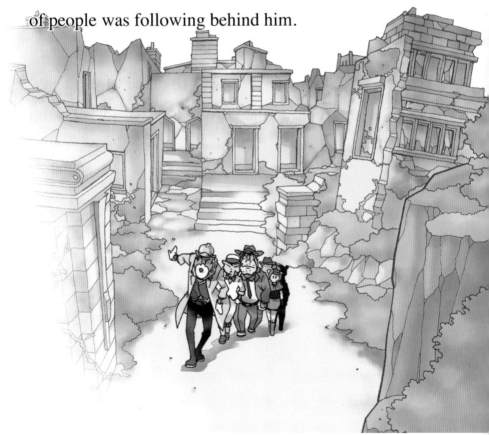

limping (形) 一瘸一拐的 aware (形) 察覺到

After passing through the graveyard, the old man headed into the **vestiges** of the ruins then stopped at a badly damaged doorway.

"He has stopped. What is he going to do?" asked Watson.

The old man walked through the doorway and disappeared.

The group picked up their steps and followed into the ruins. As they approached the doorway, they discovered that it was the doorway to a stone chamber. It appeared that this was a room in the now desolate mansion. The four walls inside were full of cracks and covered with

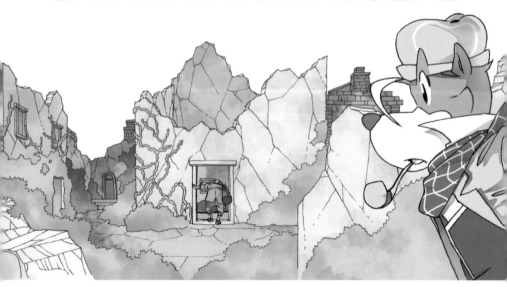

vestige(s) (名) 殘留部分 desolate (形) 荒廢的

vines, but the structure still seemed to be intact, **sturdy** enough to take shelter from the wind. But for some unknown reason, a mound of earth piled high to the waist was gathered at the centre of the stone chamber.

Standing behind the mound of earth, only the top half of the old man's body could be seen as he lowered his head to look down at something.

"What is he doing behind that mound of earth?" asked the bewildered Watson.

As soon as Watson finished uttering his question, the old man suddenly bent down and disappeared behind the mound of earth.

vine(s) (名) 藤(植物)　intact (形) 完整的　sturdy (形) 堅固的

"Hmm?" Holmes *furrowed* his eyebrows then quickly walked over to take a look.

"Oh my God!" exclaimed Holmes as soon as he reached the other side of the mound of earth.

"What is it?" said the startled Watson. The group also followed suit to see the situation for themselves.

Just one look and everyone in the group was stunned speechless.

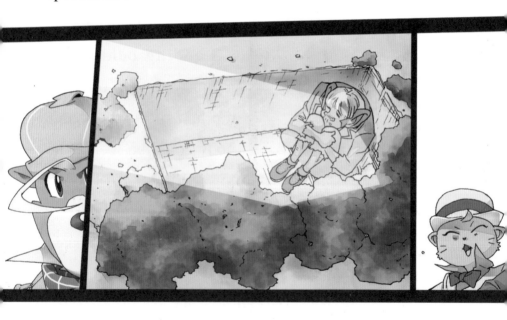

Hugging his legs to his chest, the old man was actually sitting inside a pit that was only about three to

furrow(ed) (動) 緊皺起

four feet deep!

"How could this be?" Watson could not believe his own eyes.

"He...he really has...turned into a vampire!" said Gorilla with his body *trembling* uncontrollably.

"He...he has...returned to his own grave," said Fox, feeling so weak at his knees that he could hardly support himself.

Alice and Jack were so frightened that they hid behind Holmes and Watson.

"Don't be absurd. He hasn't turned into a vampire," opposed Holmes flatly. "According to legend, vampires are afraid of sunlight. But look here, the rays from the sunset are shining right into this pit. If he were really a vampire, why would he choose to sit here?"

The stone chamber had two windows. Just as Holmes had pointed out, sunset rays were shining right through one of the windows and into the pit.

Gorilla took a nervous gulp and said, "Could it be because he hasn't completely turned into a vampire yet,

trembling (tremble) (動) 顫抖　　legend (名) 傳說

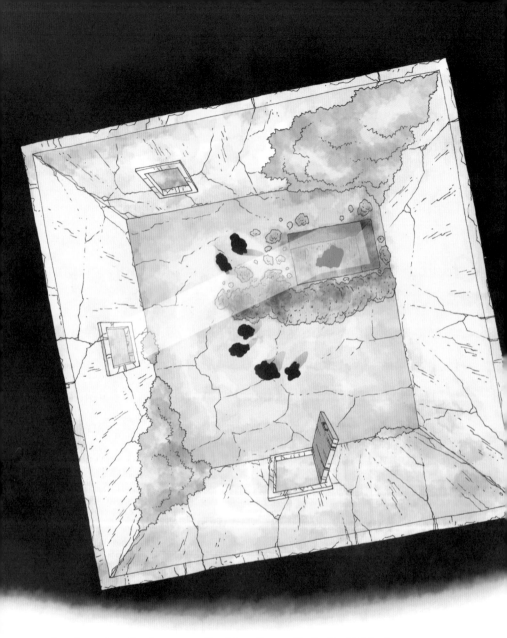

that's why he's not afraid of sunlight? Didn't you see

two teeth marks on his arm earlier?"

"Oh, come on! The space between the two teeth marks is so narrow that it can't possibly be bitten by a vampire," said Holmes with a sigh of annoyance.

"Those are the marks of a snakebite. They have nothing to do with vampires," added Watson.

"Could he have been bitten by that grass snake we saw earlier?" asked Alice.

"Very likely," replied Holmes.

Still ignoring the group, the old man leaned back on the wall in the pit with his eyes closed, as though he was relaxing on a sofa and resting his eyes.

Holmes went beside the mound of earth, picked some up with his hand then took a look and a sniff.

"What is it? Is there something unusual about the earth?" asked Watson.

"The earth is rather damp, which means this pit is newly dug, maybe less than a week ago," said Holmes.

annoyance (名) 惱怒、不耐煩　　sniff (名) 嗅一嗅　　damp (形) 潮濕的

"What does that mean?" asked Watson.

"It means that even if this were a grave, it's a newly dug grave. But the length of the pit isn't long enough to fit a coffin, so this pit probably isn't a grave."

"This isn't a grave? That's good to know," said Gorilla as he exhaled a breath of relief.

"But if this weren't a grave, then what could it be?" asked Fox. "Besides a vampire, who in the world would dig a hole in the ground to sleep in a place like here?"

exhale(d) (動) 呼氣

The Label on the Beer Bottle

"There are only two possibilities. Either the old man dug the pit himself or it was dug by someone else," said Holmes. "But since the old man is physically frail, it's

unlikely he has the strength to dig this pit."

"If that's the case, the pit must be dug by someone else," said Watson.

"But why dig a pit here?" asked Alice.

Without offering a reply, Holmes turned to Jack and asked,

"What do you think? If you were the one who needed to dig a hole here, what would be the

frail (形) 虛弱的

most plausible reason?" Watson could tell that Holmes was using this opportunity to train Jack in deductive reasoning.

"Well…" Jack thought for a moment then said, "One plausible reason could be that I think a treasure is buried in this ground. I need to dig here to hunt for the treasure, just like tomb raiders digging graves to steal precious articles that are buried with the dead."

"That sounds reasonable. What else?"

"I know!" jumped in Alice. "Besides treasure hunting, digging a hole could also be used to bury something, just like tomb raiders would need to hide their loot."

"Very insightful. Even though it is the opposite of Jack's deduction, it supplements the insufficiency in Jack's thinking," said Holmes.

plausible (形) 有可能的、似合理的　tomb raider(s) (名) 盜墓者
precious (形) 貴重的、珍貴的　loot (名) 贓物、掠奪物　insufficiency (名) 不足

"When people look at a situation, they often only see the front and overlook the back. The 'front' of digging is 'to unveil, to search', but the 'back' could be 'to use the dug up material, such as the earth, to shroud something in order to achieve the goal of hiding or burying'."

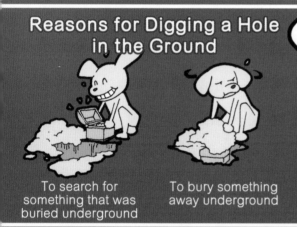

Reasons for Digging a Hole in the Ground

To search for something that was buried underground

To bury something away underground

"If someone really were searching for something here, what could he or she be searching for?" asked Gorilla.

"I don't know," said Holmes. "But we can rule out the possibility of a tomb raid because, just as I've mentioned

shroud (動) 遮蓋

before, this pit is too small to be a grave. Also, besides a church, tombs are rarely built indoors."

"Maybe this pit is used for burying something then," said Fox.

"Seems unlikely too," objected Watson. "If someone were trying to bury something, the pit should be filled with earth and not looking like this right now."

"Sounds reasonable," said Holmes. "Which is why I think the digger might've wanted to bury something at first but gave it up at the end for some reason. That's why there is a dug up hole with no earth filled in."

"For some reason? What could be the reason then?" asked Gorilla.

"I don't know yet, but it could have something to do with this old man."

"Why do you say that?" asked Fox.

"Because the timing fits," replied Holmes. "This pit was only dug up a few days ago. And based on the villagers' **alleged** vampire sightings, the old man also only began to roam around this area a few days ago. This means that the old man and this pit both appeared **out of the blue** at the same time. And the old man walked into the pit himself to sleep. That can't be a **coincidence**."

"To be honest, I kept wondering to myself just now, why did this old man walk into a pit to sleep?" said Jack. "It can't be comfortable sleeping like that."

"Good question!" praised Holmes. "I'm also

wondering the same thing. I also believe that once we know the answer to that question, we would know who dug this pit and what exactly he or she was planning on burying."

alleged (形) 聲稱的　out of the blue (習) 突然　coincidence (名) 巧合

"But how do we go about finding this digger from the vast population?" asked Alice.

"We start from him, of course," said Holmes as he pointed his finger at the old man in the pit.

After saying those words, Holmes jumped into the pit and said to the old man who still had his eyes shut, "Sir, may I look through your pockets please?" The old man did not respond to Holmes's request at all, as though he could not hear Holmes.

Holmes had no choice but to start searching through

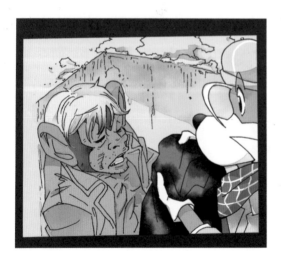

the old man's pockets without his **consent**. The pockets were empty. Holmes then quietly opened the old man's bag to see what was inside.

"Did you find

consent (名) 同意

anything?" asked Watson.

"Only these two items," said Holmes as he pulled a beer bottle and a small wooden rod out from the bag.

Watson took the small wooden rod for a thorough look and said, "This small rod is made out of **walnut wood**. From the **engraving** on the surface, this is probably a component from a piece of furniture."

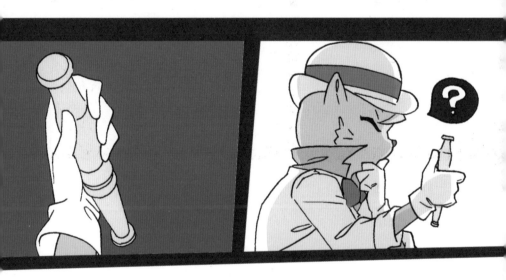

"What about the beer bottle?" asked Fox.

"It appears to be a normal beer bottle. Here, why don't you take a look," said Watson.

rod (名) 棍　walnut wood (名) 胡桃木、核桃木　engraving (名) 雕刻

"I don't see any beer inside," said Fox after he took the bottle from Watson and raised it to his eyelevel. Fox then removed the stopper and took a hard sniff at the mouth of the bottle, "There's no beer odour either. Perhaps it's an empty bottle that was used for holding water."

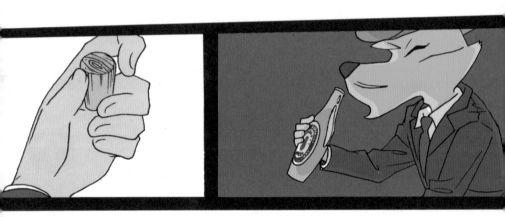

"Does this mean there are no clues?" asked the disappointed Jack.

"Take another careful look. No need to make conclusions so briskly just yet," said Holmes as he lifted the sleeping old man and carried him out of the pit.

"The bottle is completely empty. What clues could it give us?" asked Gorilla.

stopper (名) 瓶塞　　odour (名) 氣味　　clue(s) (名) 線索　　briskly (副) 草率地、匆忙地

After gently laying down the old man by the wall, Holmes specified to the group, "I'm not talking about the inside of the bottle but the outside instead. Read the label carefully. Can't you see that it offers many clues?"

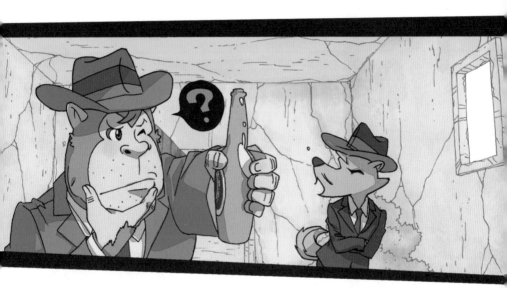

The baffled Gorilla took a look at the label and mumbled, "What clues? The label only has the brand, the alcohol content, the production date and the number 00138 printed on it."

"Don't you understand? Except for the alcohol content, the rest are all important clues," said Holmes with a shrewd smirk.

mumble(d) (動) 低聲說、嘀咕 alcohol content (名) 酒精含量

Pointing at the label on the bottle, Holmes began to explain the meaning behind each piece of information.

①The brand on the label is Thomas Beer. Thomas Brewery is a family-run brewery that only sells their products within the town of Thomas and nearby areas. Thomas is about a hundred miles from here. If the old man had brought this bottle from the town of Thomas to this place, then it is very possible that he is actually from Thomas.

②The production date printed on the label reads September 1882, which means this beer was produced this month and this bottle is very new. This is a very important clue. If the date were old and not recent, then there stands a chance that the bottle has travelled from Thomas to another town before reaching here, meaning it's nearly impossible to figure out exactly where the old man obtained the bottle.

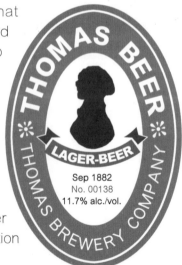

THOMAS BEER

LAGER-BEER

THOMAS BREWERY COMPANY

Sep 1882
No. 00138
11.7% alc./vol.

③The 5-digit number 00138 is the production record number.

brewery (名) 酒廠

"Mr. Holmes, you are so knowledgeable!" marvelled Alice. "One look at the label and you know exactly where the brewery is located."

"That's because Holmes is a fanatic at collecting things. Besides stamps, matchboxes and tobacco shreds, he also has a vast collection of beer and whisky bottle labels, over a thousand easily. So he is well versed in the place of origin of beers," explained Watson with a smile.

Sore at how everyone was admiring Holmes's cleverness, Gorilla huffed, "Have you guys not noticed? The ragged clothes on the old man indicate that he has been homeless for some time. Even if the old man had

been to Thomas, we still might not be able to figure out his identity."

"Sounds reasonable," said Holmes. "Not only are his clothes old and ragged but also covered with filth. He

marvel(led) (動) 感到驚奇讚歎　fanatic (名) 狂熱者　tobacco shred(s) (名) 煙草絲
well versed (形) 精通的、熟知的　sore at (形) 感到不快　huff(ed) (動) 怒氣地說
filth (名) 污物

looks as though he hasn't changed his clothes or taken a bath in many days. Perhaps he hasn't just run away or gone missing recently."

"Ha! My observational skills aren't too **shabby** either, eh?" said Gorilla smugly, pulling himself back in the game.

"However..." Holmes took a pause then pointed at the old man's shoes, "His shoes look rather new compared to his clothes."

"Erm..." Gorilla was lost for words. He pondered for a moment then came back with his counter-argument, "Oh, I know why! He found those shoes in the streets. That's why his shoes look newer than the rest of his clothes."

"What about his socks? How do you explain those?" asked Holmes. "His socks look pretty new too. Don't tell me he also just happened to have picked up a pair of socks in the streets?"

"You can only see a small part of his socks. How can

shabby (形) 差勁的、不體面的 counter-argument (名) 反駁的論點

you tell they're rather new?" argued Gorilla.

"No need to argue over that. Just take off one of his shoes and we'll be able to see clearly," said Alice as she approached the old man to take off his shoes.

The old man's shoelaces were tied with a bow. Alice *tugged* the ends of the shoelaces lightly and the knot loosened right away. She then gently pulled the shoe off the old man's foot, trying her best not to wake up the old man.

As he watched Alice untie the old man's shoelaces, a glimmer flashed across Holmes's eyes, as though he had discovered something significant.

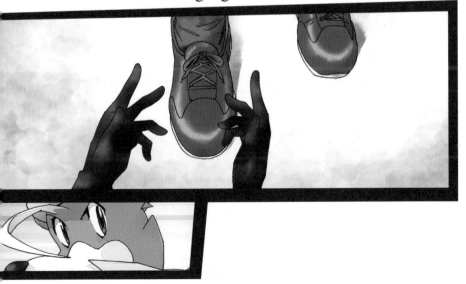

shoelace(s) (名) 鞋帶　tug(ged) (動) 拉、扯

The Truth within
the Shoelaces

"His sock doesn't look too dirty, much cleaner compared to his clothes," said Alice.

"Can you take off his sock for a look please?" said Holmes.

"Okay," said Alice as she gently pulled the sock off the old man's foot.

"The old man's foot is covered with filth. It's very dirty," said Watson. "Perhaps it's been a few months since the last time he washed his feet."

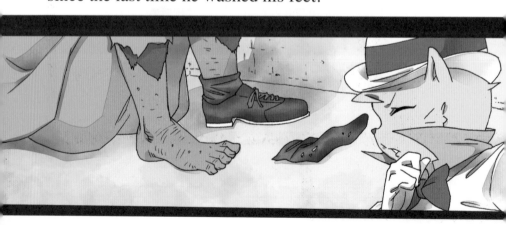

Unperturbed by the foul odour on the old man's foot, Holmes knelt down next to the old man to inspect his foot and sock, "The sock is relatively clean compared to his foot. I only see bits of something that look like wood chips on the sock. This means the old man's feet have been dirty for a long time, then relatively clean socks were put on his unwashed feet. Looking at the cleanliness of this sock, perhaps it has only been worn for two or three days."

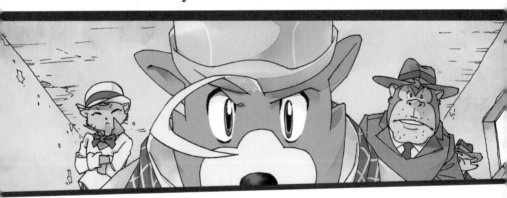

"That doesn't prove anything," argued Gorilla. "Maybe the old man found the pair of socks and shoes somewhere at the same time then put them on. It's as simple as that. When people clear things from their homes, they tend to *dispose* similar items together."

"But socks and shoes aren't similar..." said Jack, his lips trembling from his fear of Gorilla. "My mother would throw away different styles of shoes when she is clearing out old shoes, but she rarely throws away socks at the same time."

"Exactly!" agreed Alice. "Only when you're clearing out old clothes would you also gather socks to throw away together."

"You kids have pretty good analytical skills," praised Holmes. "Socks and shoes may seem like similar items but, in actuality, they're fundamentally different. Firstly, their material is different. Shoes are made with tougher material like leather while socks are made with textile. Secondly, shoes and socks are kept in different places. Shoes are usually kept in shoe racks while socks are usually kept in a dresser with other clothes. Items that are disposed together are usually stored in the same place when people tidy their homes."

"If that's the case, it's highly unlikely for the old man to have found a pair of socks and shoes off the street at

fundamentally (副) 根本上　　textile (名) 紡織品　　tidy (動) 整理

the same time." Watson thought for a moment then continued, "What if those were given to him? That would explain why the old man put on relatively new socks and shoes at the same time."

"Socks and shoes, socks and shoes… What good is it to have such a long discussion about socks and shoes? Don't tell me that we can figure out his identity from this lead," complained the *impatient* Fox.

"I can't say for sure, but having clarity on this information should improve our chances of figuring out his identity," said Holmes. "Because Watson is right about the socks and shoes being gifted to the old man. Moreover, it's possible that the giver was the one who put the socks and shoes on the old man and brought him here two three days ago."

"How could you be so certain from just his socks and shoes?" asked the sceptical Fox. "Is this a shot in the dark ?"

lead (名) 線索 impatient (形) 不耐煩的、焦急的 clarity (名) 清晰、清楚
a shot in the dark (習) 瞎猜

"Of course this isn't a shot in the dark," said Holmes as he explained his **deduction**.

① According to the villagers, the old man is first spotted roaming around the ruins two three days ago, which means it's very likely that he has only arrived here two three days ago.

② The mound of earth besides the pit shows that the pit is recently dug, possibly also dug just two three days ago.

③ The old man's socks and shoes are so clean that they've probably only been worn for two three days.

④ The way his shoelace knots are tied show that someone has tied the shoelaces for the old man. From this observation, I deduce that someone put the socks and shoes on the old man two three days ago.

deduction (名) 推論

"From the aforementioned points, I can conclude that the old man's socks and shoes came from somewhere else. Since the villagers believe so firmly in the vampire legend, they must've been **terror-stricken** when they saw the old man, which means they can't possibly be the ones who gave the socks and shoes to the old man, let alone putting

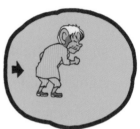

them on for him. Those socks and shoes were probably already put on the old man before he came to the ruins, and they were probably put on by somebody who knew the old man, because it's highly unlikely that a complete stranger would help a filthy and smelly homeless man put on socks and shoes," analysed Holmes. "From that, I deduce that this somebody is the one who brought the old man here from another town. The old man is very frail so he can't possibly have walked all the way here by himself. And from the label on the beer bottle, this 'other town' could be the town of

aforementioned (形) 上述的、前面提及到的 terror-stricken (形) 嚇壞的

Thomas, which is about a hundred miles from here."

"Yes, your reasoning makes sense," said Watson. "But how could you tell from the shoelace knots that they were tied by someone else and not the old man himself?"

"Have you not noticed?" said Holmes as he let out a shrewd chuckle. "The old man carried his bag on his right shoulder. That's the habit of a right-handed man. Also when I was feeding him water, he used his right hand to hold the canteen. This, again, indicated that he is right-handed. If the shoelaces were tied by the old man himself, the small overlapping loop knot should be tied to the right if looking from the angle of the old man himself (toe side pointing away from himself), tied to the left if looking from our angle (toe side pointing towards us). This is how a right-handed person would tie a bow. However, that overlapping loop knot is now tied to our right. This means someone else standing opposite the old man has tied the shoelaces for him."

overlapping (形) 重疊的　　loop knot (名) 環結

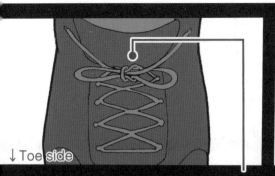

↓ Toe side

If the old man had tied the shoelaces himself, this small overlapping loop knot should be tied to the left.

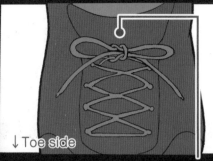

↓ Toe side

But the small overlapping loop knot is tied to the right. This shows that someone else has tied the shoelaces for the old man.

"Mr. Holmes, you are so amazing!" exclaimed Alice. "I didn't notice that detail at all when I was untying the shoelaces!"

"Eh? What is that? It looks like a candle," said Jack all of a sudden while pointing at the bottom of the pit.

"The old man's body must've covered it when he was sitting inside. The candle has only come into view after I carried him out from the pit," said Holmes as he jumped back into the pit. He picked up the candle for a look then pulled out his magnifying glass from his pocket for a closer inspection of the spot where the candle was found.

magnifying glass (名) 放大鏡 inspection (名) 檢查

"What do you see?" asked Watson.

"There are a few drops of wax on the ground. Perhaps they were *splattered* on the ground when the candle was dropped."

"So the candle was lit when it was dropped?" asked Jack.

"It's also possible that someone blew out the candle then dropped it before the wax by the wick had time to **solidify**," said Holmes.

"Oh, I get it!" said Alice enthusiastically. "Someone must've lit the candle while he or she was digging this pit and just casually threw the candle into the pit before leaving. That's how those drops of wax got splattered."

"A decent analysis indeed," said Holmes lightly. "The candle also tells us that whoever lit the candle must've left this place during the night, because it wouldn't be

splatter(ed) (動) 飛濺　　wick (名) 燭芯　　solidify (動) 凝固
enthusiastically (副) 興奮地、激動地

82

necessary to light a candle if it were daytime. Whoever this is must've come here on a secret mission. This person must've been afraid to be seen by other people during the day since he or she had **opted** to come here at night knowing that this place is rumoured to be **haunted**."

"Sounds reasonable," said Watson. "But it's still difficult to connect the dots from what we have gathered so far."

"Is that really so?" Holmes *tore out* a sheet of paper from his notebook and drew a chart to show the connections between all the clues they had found.

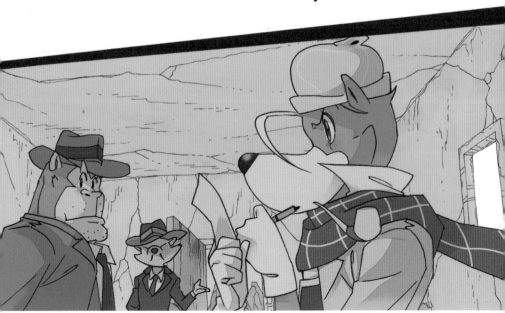

opt(ed) (動) 選擇　　haunted (形) 鬧鬼的　　tore (tear) out (動+介) 扯出、扯掉

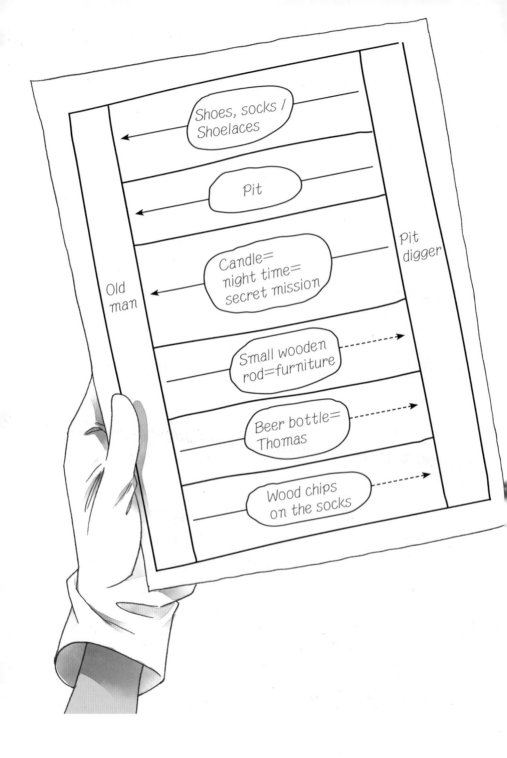

84

"Come take a look at this chart. Between the old man and the pit digger are the clues that we've gathered so far. The arrows with solid lines indicate established connections between the old man and the pit digger. Listed in **chronological** order, the pit digger put socks and shoes on the old man and tied the shoelaces for him. The pit digger then brought the old man here and dug the pit. The digging was done at night so a lit candle was needed. Even though we don't know yet why the pit digger brought the old man here or the reason behind digging the pit, we do know it must've been a secret mission," explained Holmes **in sequence**. "The arrows with dotted lines indicate items where connections between the old man and the pit digger have not been established yet, namely the small wooden rod, the beer bottle and the wood chips on his socks. But if we were to look the other way around, all we need to do is figure out how these three items are connected between the old man and the pit digger and we should be able figure out the identity of this mystery pit digger."

chronological (形) 按時間先後次序的　　in sequence (片語) 順序

"I see," said Watson. "If that's the case, shall we head to Thomas next?"

"Of course! We shall go ask the local police station in Thomas and see if there had been any missing persons reported," proposed Gorilla right away.

"That's an excellent suggestion. But it's getting dark already. Mr. Ferguson is awaiting us for dinner. Let's wait till tomorrow to head to Thomas," said Holmes.

"Yes," agreed Watson. "We also need to find a place to settle the old man so I can give him a thorough check-up."

"Why don't we bring him back to my house?" suggested Jack. "We have many guestrooms. I'm sure my father wouldn't mind at all."

The Town of Thomas

The next morning after spending a peaceful night at the Fergusons, Holmes hopped into a horse-drawn carriage with the old man, Watson, Gorilla, Fox, Alice and Jack and headed to the town of Thomas.

During the carriage ride, Watson informed the group of the old man's health condition. Last night, when Watson bathed the old man and helped him change to

hop(ped) into (動＋介) 跳入 condition (名) 狀況

clean clothes, Watson found many **festering sores** on the old man's buttocks and back. The old man's teeth had almost all fallen out. His badly *atrophied* leg muscles indicated that he probably did not walk much. Moreover, Watson also found the old man's *cognitive* ability to be very poor and appeared to be suffering from severe **dementia**.

"He's suffering from dementia. No wonder he didn't respond to us and just went about doing his own thing," said Holmes.

"Most dementia patients can only remember things that happened during their younger years. The more recent the events, the less likely they'll retain any memory of them," explained Watson. "That's why you were only talking over his head when you questioned him. Any attempt to get an answer from him would be *futile*. Severe dementia patients can't even remember their own names, nor the names of their children and where they live. But their cognitive ability could be **inconsistent**. Sometimes they would suddenly remember things and sound like their minds are working well again."

festering sore(s) (形+名) 化膿、潰爛的傷口　　atrophied (形) 萎縮的
cognitive (形) 認知的　　dementia (名) 認知障礙症　　futile (形) 無用的
inconsistent (形) 反常、不一致

"Let's hope that his memory would suddenly return and be able to tell us his own name," said Gorilla. "If he really were a resident or homeless man from Thomas, we would be able to identify him at the local police station once we know his name."

After riding in the carriage for half a day, the group finally reached the town of Thomas. Unfortunately, the local police had received no reports on a missing old man or homeless man. Just like before, the old man did not respond at all to the police questioning, so his identity remained a mystery.

"We haven't learnt anything new. I guess this lead ends here," said the **dejected** Gorilla and Fox as they stepped out of the local police station.

"No, this isn't the end yet," said Holmes with confidence. "We still have that beer bottle."

"Are you talking about that label? The information on the label has already brought us to this town. Are there other clues on the label?" asked the puzzled Watson.

"Of course," said Holmes. "Remember that production record number 00138? With that number, we can go to the beer brewery and inquire to which **liquor shop** this bottle was sold. If we could locate the buyer of that particular bottle of beer, maybe the buyer could lead us to the identity of the old man.

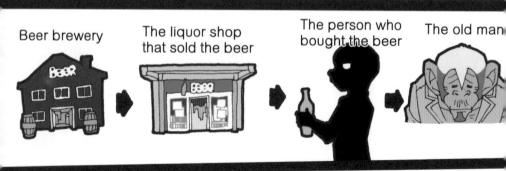

Beer brewery | The liquor shop that sold the beer | The person who bought the beer | The old man

dejected (形) 沮喪的、灰心的　　liquor shop (名) 賣酒的商店

Just as our great detective had **anticipated**, one look at their wholesale record book and the beer brewery was able to provide the name and address of the liquor shop where that particular beer was sold.

anticipate(d) (動) 預料

"Yes, our shop did sell this bottle of beer," said the liquor shop owner after he flipped through his procurement records and found that particular number written in his book.

"Do you remember to whom you sold that beer?" asked Fox.

"I can't say I remember," said the liquor shop owner with a bitter smile. "It's not like I make a record of what every customer buys from my shop."

"Fair enough," nodded Holmes. He then pointed his finger at the old man standing outside the liquor shop and asked the shop owner, "Would you happen to recognise that old man? Does he live around here?"

procurement (名) 採購　　nod(ded) (動) 點頭

The liquor shop owner took a look and shook his head, "I've never seen him before. I would recognise him if he is from this area."

Holmes thought for a moment then asked again, "Is there a furniture store nearby?"

"Yes," replied the liquor shop owner right away without a second of hesitation.

A glimmer flashed across Holmes's eyes before he continued to ask, "Has anyone from the furniture store bought beer from you recently?"

"Erm…" The liquor shop owner *scratched* his head and said, "I think so. The owner of that furniture store

scratch(ed) (動) 抓癢、搔癢

comes here **every now and then** to buy drinks. But has he come by recently…?"

"It's fine if you can't recall exactly. Can you tell me where is this furniture store and what is the name please?"

"It's called Goudier Furniture Store. Their workshop is at the back of the store. The owner's name is Devon Goudier. The store is only a five-minute walk from here," said the liquor shop owner as he wrote down the address on a sheet of paper. "But the store owner's wife is not a very pleasant woman, a bit of a **shrew** really. Everyone in the neighbourhood stays away from her as much as possible. No one wants to work for them either. I suggest you don't go over there."

"Oh, really? Thanks for the advice."

After thanking the liquor shop owner, Holmes completely ignored the shop owner's advice and headed straight to the furniture store with the rest of the group.

every now and then (習) 時常、久不久　　shrew (名) 潑婦

"Mr. Holmes, are we looking for the furniture store because you found that small wooden rod in the old man's bag?" asked Alice as they were walking. "I remember Dr. Watson said that rod is a furniture component."

"Your memory serves you well. Yes, that small wooden rod is key," said Holmes as an enigmatic smile appeared on his face. "But there was also something else that led me to associate my thinking to furniture store."

"What is it?" asked Jack curiously.

"You'll know once we are there."

A moment later, Holmes, the Scotland Yard duo, Jack and Alice had arrived at the front door of the furniture store. Watson and the old man were still lagging far behind as Watson had to take care of the old man who was walking very slowly.

"To not sound off any alarm, I will go inside with Alice first for a look around. When the timing is right,

lag(ging) (動) 落後

I'll ask you all to come in," instructed Holmes.

After saying those words, Holmes whispered something in Alice's ear before stepping into the furniture store with her. Once inside, Holmes raised his voice and asked to see the owner.

A **hunched back** middle-aged man came out from the back of the store as soon as he heard Holmes's voice. Behind the middle-aged man was a middle-aged woman who looked irritable and cantankerous. Without a doubt, this couple was the Goudiers, the owners of the furniture store.

Goudier asked in a **flattery** tone as he *stooped* and *rubbed* his palms together, "Hello, sir! Are you looking to buy new furniture? Our store offers ready-made items, but we also do custom-made."

Holmes greeted the owner with a smile on his face, "Oh, you must be Mr. Goudier. A friend of mine has recommended your store to me, so I'm here today with my daughter. I want to have a set of furniture made and I would like to include this piece in the decoration."

hunched back (形) 弓着背的　　irritable (形) 容易發怒的
cantankerous (形) 難相處的、愛吵架的　　flattery (形) 奉承的
stoop(ed) (動) 彎着腰、俯身　　rub(bed) (動) 擦着

98

Holmes pulled out the small wooden rod from his pocket as he spoke.

"My father and I are very fond of this kind of decorations. Can we include it in our new furniture?" said Alice to Devon Goudier as she brought the small wooden rod before his eyes. Obviously, Holmes and Alice were pretending to be father and daughter to not raise any suspicion.

Goudier took the small wooden rod for a look and said, "This? This is called a **spindle**. It is commonly used as a component on the back of a chair. It just so happens that we have a chair here with the same decorative spindle. Would you like to see it?"

"Brilliant! I'd love to see it!" said Alice vivaciously.

spindle (名) 椅背軸柱、繞線軸　　vivaciously (副) 活潑地、高興地

Goudier walked over to a chair inside the store and said, "This is the chair. As you can see, the spindles of this chair are the same as yours."

Holmes walked over and stroked the back of the chair then said admiringly, "Ah yes, they really do look the same. Even the size and wood quality are similar."

Thinking that Holmes was considering a purchase, Goudier's wife stepped forward to **pitch the sell**, "If you and your daughter are interested in buying this, I can offer you a discount."

pitch the sell (習) 竭力推銷

"Really? That's so kind of you," said Holmes as he knelt down and pretended to take a closer look at the legs of the chair. Using his back to block the Goudiers' view, Holmes quietly picked up some wood chips on the floor and gave them a sniff.

As Alice watched Holmes, she suddenly came to realise Holmes's intention, Wood chips! Wood chips were stuck on the old man's socks! Besides the spindle, Mr. Holmes must've associated the old man with furniture store because of the wood chips on his socks! If that's the case, then two dotted lines on the chart have now

associate(d) (動) 聯繫起來

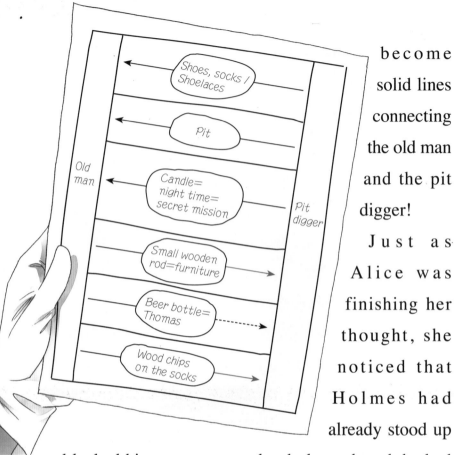

become solid lines connecting the old man and the pit digger!

Just as Alice was finishing her thought, she noticed that Holmes had already stood up and locked his eyes on a nearby desk, as though he had discovered something **significant**.

Alice followed his line of sight at once, but the desk just looked like an ordinary wooden desk to her. A desk was not written in the chart of clues, so why did Holmes appear so startled by this desk?

What Alice did not know at that moment was that this

significant (形) 重要的

ordinary desk would not only reveal the connection between the old man and the furniture store, it would also expose a tragedy so appalling that it was even beyond Holmes's imagination.

reveal (動) 顯露、披露、揭露　tragedy (名) 悲劇　appalling (形) 驚人的

The Secret in the Desk

A glimmer flashed across Holmes's eyes before he pointed his finger at a small hole on the desk drawer and asked **nonchalant**ly, "This hole in the desk drawer is very unusual. It is drilled right at the spot of a **wood knot**."

"That small hole? You have very good eyes, sir. That hole is for installing a lock. The appearance is much more pleasing if the hole is drilled at the spot of a wood knot. Also, this desk is made of Brazilian rosewood, so it really is a luxurious piece," said Goudier, trying his best to push the sell. "This particular piece is already

nonchalantly (副) 不以為然地 at the spot (片語) 位置 wood knot (名) 木節
Brazilian rosewood (名) 巴西黑黃壇木 luxurious (形) 豪華的

bought by a customer. If you really like it, I can make you another one."

"Really? I would like that," said Holmes, showing immense interest. "But let me ask my friends who are waiting outside the store and see if they also think it is worth the money." After saying those words, Holmes signalled Alice with a look. She then went outside to ask the group to come in.

"Friends outside? You have friends waiting outside?" The Goudiers thought it was strange, but before their suspicion subsided, Gorilla and Fox had already walked into the store with Jack, Watson and the old man.

immense (形) 極大的 subside(d) (動) 消失、減退

As though they were struck by lightning, the Goudiers appeared to be extremely terrified the moment the old man stepped "*shakily*" into the store.

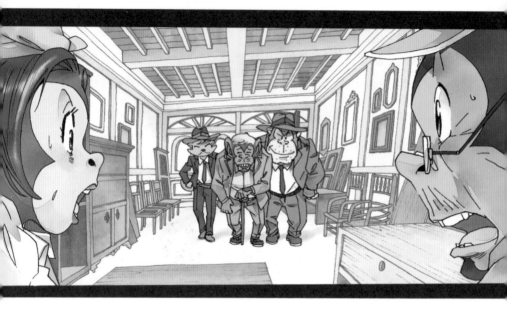

"You look surprised. You must know this old man." Holmes's bland words seemed to have turned into sharp daggers piercing the Goudiers right at their hearts.

"Sir, is this…a joke…? Who…who is this old man? I…I've never seen him before… I don't…I don't know him…" Perhaps he was in too much of a shock, Goudier spoke with a fearful stammer.

shakily (副) 虛弱地、顫抖地　　dagger(s) (名) 短刀、匕首
stammer (名) 結結巴巴地說話、口吃

"What is this nonsense?" Compared to Goudier, his wife was much quicker on the draw. She raised her voice to cover up her shock and said *emphatically*, "We don't know this old man!"

"You don't know him?" said Holmes slowly as he let out an icy chuckle. "Watson, bring me the bottle please."

"The bottle? Here you go," said Watson, pulling the empty beer bottle right out of the bag and handed it to Holmes.

Holmes took the bottle from Watson's hand then showed it before the Goudiers' eyes and asked impassively, "If you didn't know this old man, why is he in possession of this beer bottle which came from here?"

One look at the beer bottle and all colours from Goudier's face faded. He took a few backward steps unwittingly as beads of cold sweat began to appear on his forehead.

Goudier's wife gave her husband a puzzled glare as though she did not understand the meaning behind the beer bottle. But one look at the fear on her husband's face and she quickly realised that this bottle must be unfavourable to them, so she shouted crossly at once, "What beer bottle? That is not ours!"

"Is that so?" Ignoring her, Holmes stepped closer to Goudier as he posed his question in an **irrefutable** tone.

"Really... It really...isn't ours..." stammered Goudier.

fade(d) (動) 褪色　crossly (副) 生氣地　irrefutable (形) 不容駁辯的
stammer(ed) (動) 結結巴巴地說

"Why do you look so frightened if this is just an ordinary beer bottle?"

"Ahaha… I'm…not frightened…" Goudier had no choice but to act calm while replying our great detective. "I… I just have no idea what you are talking about."

"These two gentlemen here are detectives from Scotland Yard. Please do not lie in front of the police." Holmes raised his hand to introduce Gorilla and Fox to the Goudiers then continued in a **stern** tone, "I will ask you one more time. Is this your beer bottle?"

Everyone in the group knew well that Holmes had deliberately mentioned the presence of Scotland Yard

stern (形) 嚴厲的

detectives in order to boost the **intimidation factor**. He wanted to take down the Goudiers' fortress, which was about to crumble.

Even though Gorilla and Fox had no idea what significance laid within the empty beer bottle, they grasped onto the opportunity that Holmes had just handed them and brandished their authority. "Tell us now! Is this yours?" shouted the Scotland Yard duo, cooperating with Holmes's performance.

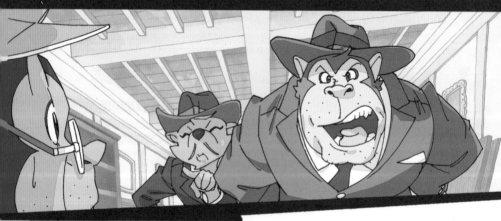

Sure enough, Goudier was so **intimidated** that his knees weakened and almost lost his balance.

intimidation factor (名) 威嚇力　　crumble (動) 崩潰、破碎
brandish(ed) (動) 炫耀　　intimidated (形) 膽怯的，畏縮的

Realising that they were losing ground, the shrew in Goudier's wife took over and shouted ferociously, "So what if you are police detectives? We are not criminals! Don't tell me that a beer bottle is enough to cook up a groundless charge against us! I'm telling you once and for all, this beer bottle isn't ours!"

"Is that so?" Holmes took a pause then glared at the Goudiers with his piercing eyes.

The stalemate only lasted for a few seconds, as it was broken off by a faint popping sound when Holmes

ferociously (副) 兇惡地　　cook up (片語動) 偽造、編造
stalemate (名) 僵持局面

pulled the wooden stopper out of the beer bottle, "You may not recognise the beer bottle, but you must recognise this."

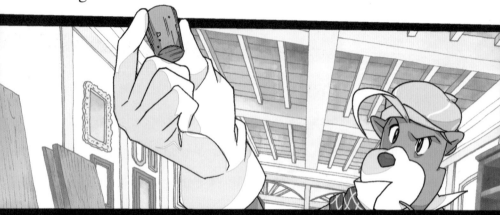

Holmes held the wooden stopper before Goudier's eyes. He then turned around sharply and placed the wooden stopper into the small hole of the desk drawer. As everyone wondered what our great detective was up to, the stopper had already slipped into the small hole like a hand in glove.

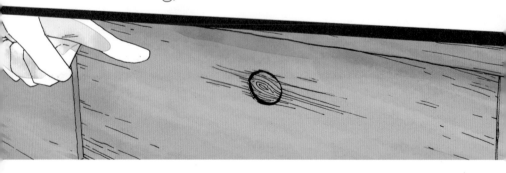

slip(ped) into (動＋介) 滑進、陷入　　hand in glove (片) 天衣無縫、恰好

"Oh!" gasped Watson and Alice. With all eyes fixed on the stopper, everyone in the group could see that the wood grain of the stopper matched exactly with the wood grain of the drawer!

That stopper was actually the wood knot that was drilled out from the drawer's front board! Just like fingerprints on humans, wood grain patterns are unique in timber. If the wood grain of the stopper matched exactly with the wood grain of the drawer's front board, it meant the stopper was originally the wood knot of that board.

"If this beer bottle didn't come from your place, how did the wood knot of that drawer end up as a stopper on the old man's beer bottle?" **interrogated** Holmes.

Staring at the wood knot on the drawer, the dumbfounded Goudiers were lost for words.

wood grain (名) 木紋　timber (名) 木材、樹木　interrogate(d) (動) 質問
dumbfounded (形) 驚呆的

The remaining dotted line on the clues chart has now established a firm connection! thought Alice.

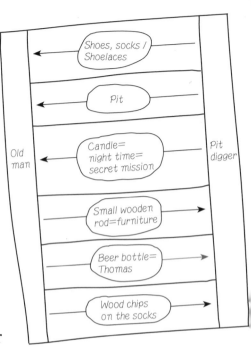

"Devon..." A **hoarse** voice suddenly sounded, breaking Alice's train of thought. Alice and the rest of the group turned their heads around to search for the speaker of this voice.

"Devon... let's leave..." The voice turned out to be the old man's, holding Watson's hand as he spoke.

hoarse (形) 沙啞的

"Old sir, what did you say?" Watson was caught by surprise upon hearing the old man speaking suddenly.

The old man raised his head to look at Watson. He pulled Watson's hand and said, "Devon, let's leave."

"Devon?" Holmes immediately turned to Goudier, remembering that the liquor shop's owner had mentioned the furniture storeowner's name was Devon Goudier!

Goudier's body **stiffened** when he heard the old man say his name. His wife's face was also shocked to a sheet of white. She definitely had not expected the old man to say her husband's name at this critical moment.

"Devon, let's leave," urged the old man again as he gave Watson another tug.

stiffen(ed) (動) 僵硬

"Father…father!" Goudier flung to the old man's knees and broke down to tears, "Devon is here! I am Devon! I am Devon… Please forgive me… Please…"

Goudier's sudden change of heart surprised everyone. Apparently, Goudier's conscience had not completely perished just yet. Hearing his father say his name had awakened the **decency** in him that had been dormant for too long deep within.

perish(ed) (動) 喪失、敗壞、死亡　　decency (名) 禮義廉恥
dormant (形) 潛藏着、沉睡着

All Came to Light

All came to light after a series of in-depth interrogations were conducted. The old man was, indeed, Goudier's father. Goudier's older sister had been taking care of their father for many years, but when his sister passed away from illness five years ago, Goudier had no choice but to take his father into his own home. The old man was suffering from dementia and episodes of incontinence happened quite often as well. Goudier's selfish wife was unwilling to care for the old man. She even blamed Goudier for causing her trouble by taking the old man home.

Under the pressure of his wife, Goudier brought his father to the furniture workshop and confined him in the cellar for the past five years, keeping him alive like a pig in a pigsty. This was why the neighbours were not aware of the old man's existence.

Years passed and the old man's health gradually

interrogation(s) (名) 盤問、審問　episode(s) (名) 事件　incontinence (名) 失禁
pigsty (名) 豬欄

deteriorated. He was in a very weak state in the past month, then three days ago, he was barely breathing while lying on the ground in the cellar. Thinking that the old man was about to die, Goudier's wife wanted to get rid of the old man as soon as possible. However, taking the old man to the hospital was not an option. They were afraid that they would be charged for abusing the elderly and they might end up in prison.

To avoid exposing themselves, she forced Goudier to chuck the old man like a bag of rubbish. Goudier refused at first, but the pressure from his ill-tempered wife was too much to bear. As he was also afraid of police charges, Goudier decided to abandon his father at the ruins of Count Dracula's mansion. Knowing that the area was rumoured to be haunted, he thought he could

deteriorate(d) (動) 惡化、變壞　to get rid of (片語) 扔掉、清除
abusing (abuse) (動) 虐待　ill-tempered (形) 脾氣暴躁的

bury his father there without ever being discovered.

Once he made up his mind, Goudier helped his father put on socks and shoes. He then picked up an empty beer bottle nearby and filled it with water for drinking while driving the carriage to the ruins. However, right after he finished digging up the pit inside the stone chamber at the ruins, the noises of someone approaching terrified him so much that he blew out the candle, left his father there and fled the scene straightaway, forgetting to take with him the sack and the beer bottle.

Never had Goudier imagined that his father would survive and be mistaken for a vampire by the villagers.

"When I left my father behind and fled... I actually felt

fled (flee) (動) 匆忙離開、逃離

relieved...because I knew that he was still breathing. If I were to bury him right then and there, that would be the same as killing him myself," confessed the exhausted Goudier in a stammer. "I...I just couldn't do it... He...he is my father...after all..."

Goudier felt **tormented**. He thought running away would end the nightmare. It had never crossed this mind that the beer bottle he used as a **makeshift** water canteen and the stopper (wood knot) he casually grabbed from the workshop would end up being key material evidence.

"My father must have taken the spindle from the workshop," speculated the dejected Goudier. "I was in the middle of making a chair at that time. I made several spindles but found one missing. That's probably the missing spindle."

The Goudiers were charged with attempted murder

exhausted (形) 筋疲力盡的 tormented (形) 苦惱、煎熬 makeshift (形) 臨時代用的

after they confessed the details. The old man was sent to an elderly care home where he could finally spend the rest of his life in peace.

"Somehow the old man woke up after he was abandoned in the ruins and started roaming around the area near the graveyard. Since he was used to living in a cellar for many years, he just naturally returned to the pit to rest when he was tired," said Holmes. "At first I couldn't figure out how the pit connected the old man to the digger, but Goudier's confession revealed that the pit was actually dug to bury a live man."

"Who could've imagined such a cruel thing?" said Watson. "You know, I was really shocked when the old man called me 'Devon'. But then again, an old man with dementia calling someone by the wrong name happens very often, so it's not particularly peculiar for the old man to have mistaken me for his son."

"Yes." Holmes nodded his head before continuing,

"But I still think the old man's dementia wasn't that far gone. There was a reason why he had only mistaken you and not someone else for his son. You helped him bathe and change into clean clothes. You also treated the sores on his back. In his mind, only one's own children would take such tender loving care of their parents. He must've sensed that you are a kind man, so he regarded you as his son."

"Perhaps," sighed Watson. "But I'm sure the old man would rather have his real son take care of him. Otherwise, why would he call out his son's name?

peculiar (形) 奇怪的

Goudier's abandoning his ailing father is absolutely unforgiveable. Parents endure all kinds of hardships in order to bring up their children, so sons and daughters should take up the responsibility to care for their ageing parents."

ailing (形) 生病的、體衰的　endure (動) 忍受

Live Knots and Dead Knots in Timber

We often see patterns that look like eyes in wooden furniture (Figure 1). Known as knots, these dark shaded circular patterns are places where branches grew from a tree trunk. Knots are categorised into live knots and dead knots. A live knot is a marking left by a live branch while a dead knot is a marking left by a dead branch. So how come a dead branch leaves a marking in a tree? It turns out that even when a branch dies and falls off, part of the branch still stays in the tree trunk sometimes. When the tree trunk grows bigger and thickens in layers, the tree trunk ends up enwrapping the remaining portion of the dead branch into the tree trunk's interior. And it is only after the tree is felled and sawn into boards that the dead knots come into view.

Figure 1

When making furniture with timber, live knots that are not dried and cracked are retained since their wood grain patterns are very pretty and enhance the ornamental quality in furniture. Dead knots, however, are usually removed since they can crack easily and even fall off. Once the dead knot is removed, the hole often needs to be filled with another piece of wood. This is why timber with many dead knots is often cheap in price and not a popular choice amongst carpenters. If there is any wooden furniture around you, try to find the knots and see if you can tell which are live knots and which are dead knots.

The arm of a wooden chair where a live knot from a cut off branch is clearly visible.

Figure 2 saw cut

Dead branch enwrapped in the tree trunk

When a branch is sawn off a tree, a live knot appears on the tree trunk (Figure 3). When a tree trunk with a dead branch enwrapped inside is cut into boards, a dead knot comes into view (Figure 4).

Figure 3

Live knots look like eyes on wood boards. They are usually kept because of their beautiful patterns.

Figure 4

Keeping dead knots on boards might result in chipping and cracking, so they are usually removed.

tree trunk (名) 樹幹 live knot(s) (名) 活節 dead knot(s) (名) 死節
enwrap(ping) (動) 包圍 ornamental (形) 裝飾性的、觀賞性的

Sherlock Holmes Cool Science Craft
DIY Cork Bottle Stopper Sailboat

The bottle stopper was key in our story this time!

Yes. That stopper was actually a wood knot. Most bottle stoppers, however, are usually made out of cork. Why don't we build a mini sailboat with a cork bottle stopper?

1

Sail

full-length toothpick

Cork bottle stopper (halved lengthways)

half-length toothpicks

Note: Cutting a cork stopper in half lengthways is rather tricky, so please ask an adult for help.

Prepare the items in the above image. When making the sail, we recommend using the plastic packaging from food packets as material for its splash-proof quality.

2

Attach the 2 half-length toothpicks to the middle of the long sides of the cork stopper on both sides to stabilise the balance, then attach the full-length toothpick on the flat side of the cork stopper as the mast.

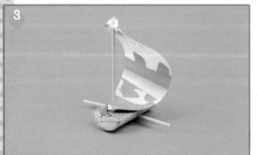

3

Curl the sail into the shape of an arc and attach it to the mast. The mini sailboat is built!

4

Place the mini sailboat in a basin and see if it floats on the water. Blow at the sail and watch the boat sail on the water!

Unfolding the Scientific Mystery

Since the average density of cork is lower than the density of water, its weight also lighter than water, cork floats on water. Attaching the two half-length toothpicks to the two sides of the cork helps to stabilise the balance of the mini sailboat and prevents it from capsizing, just like a tightrope walker holding a long pole horizontally for balance. Toothpicks are also lighter in weight than water, so the toothpicks actually help boost the buoyancy of the mini sailboat.